MW00488879

To Rhys:
 Spread your joy♡!
Every Day!!!!
 ...& Enjoy♡!
 Sweetheart

The Duck Pond Hawk

Copyright 2022

SME Publishing
Susan Murray Euart
2612 Parkside Drive
Atlanta, Georgia 30305

All rights reserved

THE DUCK POND HAWK
Third Printing

ISBN 978-0-615-46165-6

Printed in the U.S.A.

Production Assistance by Burt&Burt, LLC
burtandburt.com

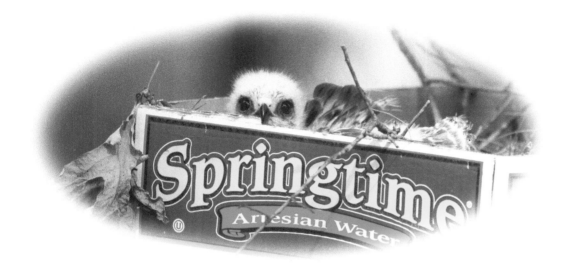

The Duck Pond Hawk

A True Story about Caring, Courage, and Growing Up

Susan Murray Euart

Dedication

First books do not happen by themselves. There are so many people to recognize. First, there is Liz and John Cox and their dog, Pearl. If they had not found the hawk that first morning and taken such care to do the right thing for the baby bird there would be no story. My husband, John, deserves a lot of credit for checking every page and making sure the words made sense . . . thanks for believing in my photography and the project. To the Fagots, my dear friends and the first to read the story thanks for the input and saying it was good. To my many editors who took the time to give me constructive criticism: Cecilia and Mary Adeline Edwards, Bob and Charlotte Margolin, Jane Murray and Linda Kelleher, you are all such wonderful friends. To each one of my children, Jef, Will, Pat, Kathleen and Casey, thanks for cheering me on.

And many, many thanks to Dolores Euart who did not hesitate in telling me to get on a plane and come to Dallas and she would help me self-publish the book. You went over and above what a sister-in-law needs to do.

Of course, the main dedication goes to all the people of the Duck Pond who loved this Red-Shouldered Hawk.

The Red-Shouldered Hawk Fact Sheet

Their tails are brownish-grey with bands of white.

Red-shouldered hawks are between 18 & 24 inches long when fully grown.

The red-shouldered hawk's favorite spot to make a nest is in forests and wetlands. The adult male and female build nests that are large and deep. They usually place the nest about 60 feet above the ground. They use sticks, twigs, bark, and leaves as building materials. Once the nest is completed, the male hawk puts green twigs around the edges of the nest to show he owns it. Red-shouldered hawks are strong and can be bullies, but they are very loyal to their mate. In February or March, the female lays about 3 or 4 eggs. While she sits on the eggs the male hunts and brings her food. After the chicks are hatched they both share hunting duties and take care of their young. They like to eat rabbits and squirrels, snakes, frogs, lizards and large insects. From the time the male bird starts looking for a mate to when the female starts to sit on her nest, the hawks scream a loud "kee-yar;" during the rest of the year they are usually quiet.

The have light brown specs on their chest.

They live in California and the Eastern United States.

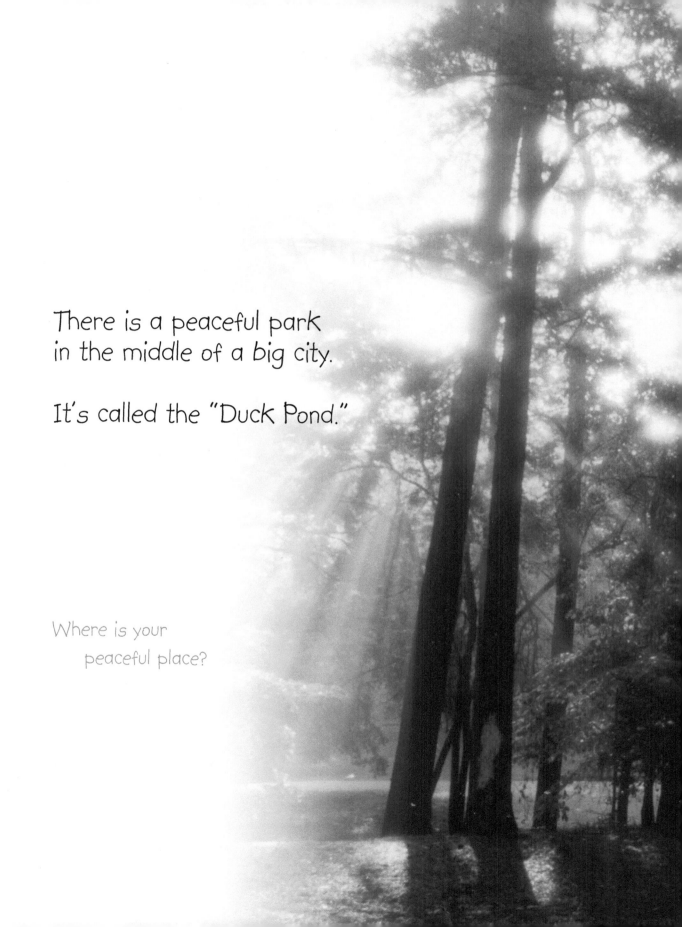

There is a peaceful park
in the middle of a big city.

It's called the "Duck Pond."

Where is your
peaceful place?

6

I am a little red-shouldered hawk.

On a dark, stormy night the wind
 blew me and my nest out of a tall
 pine tree near the duck pond.

I was so scared!

When have you been scared?

8

The next morning, when the sun came up,
 I was still really scared!

A gigantic dog named, Pearl,
 found me on the ground in my nest.

Pearl's owner scooped me up and called for help.

When have you had to ask for help?

The really nice owner put me in a shallow box and placed me underneath the tall pine tree out of which I had fallen.

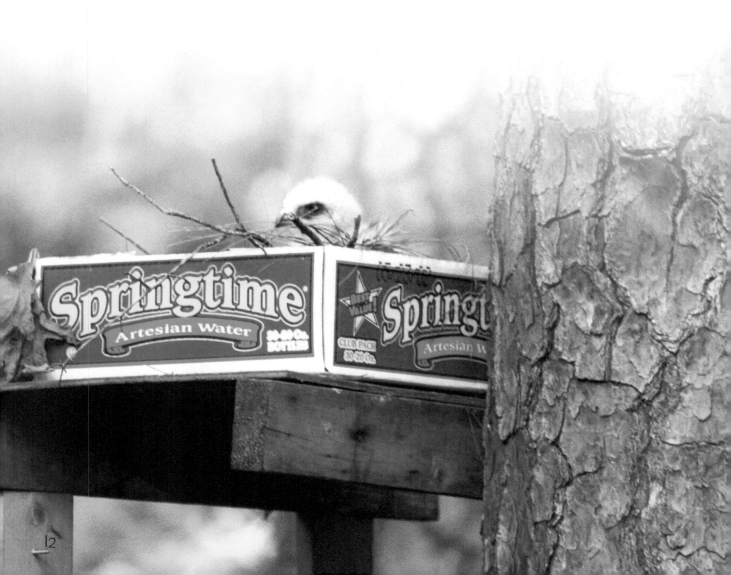

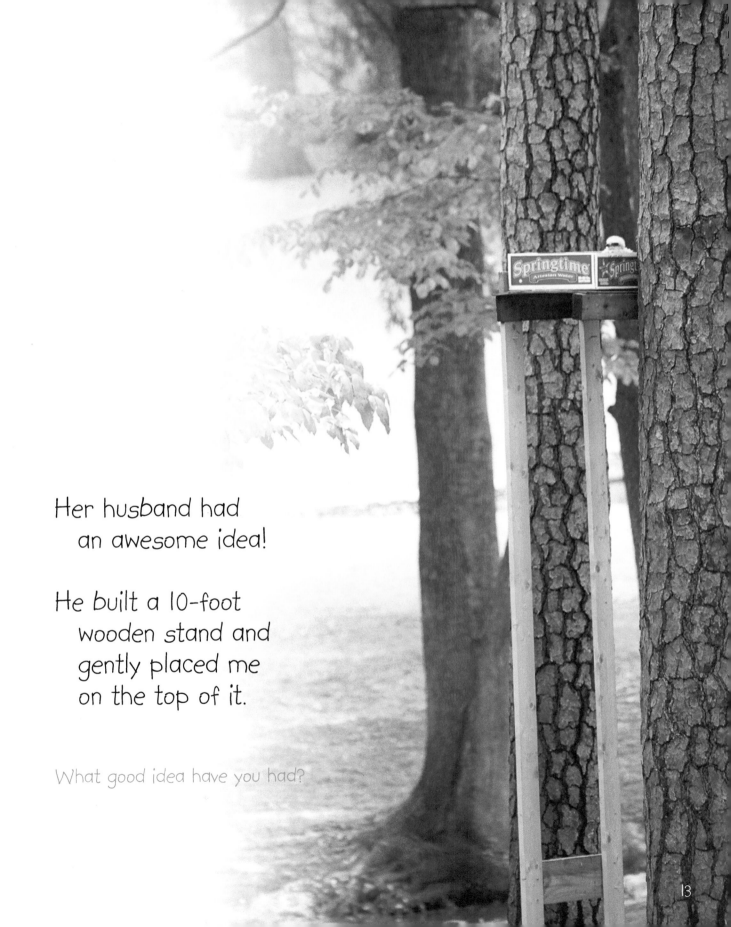

Her husband had
 an awesome idea!

He built a 10-foot
 wooden stand and
 gently placed me
 on the top of it.

What good idea have you had?

13

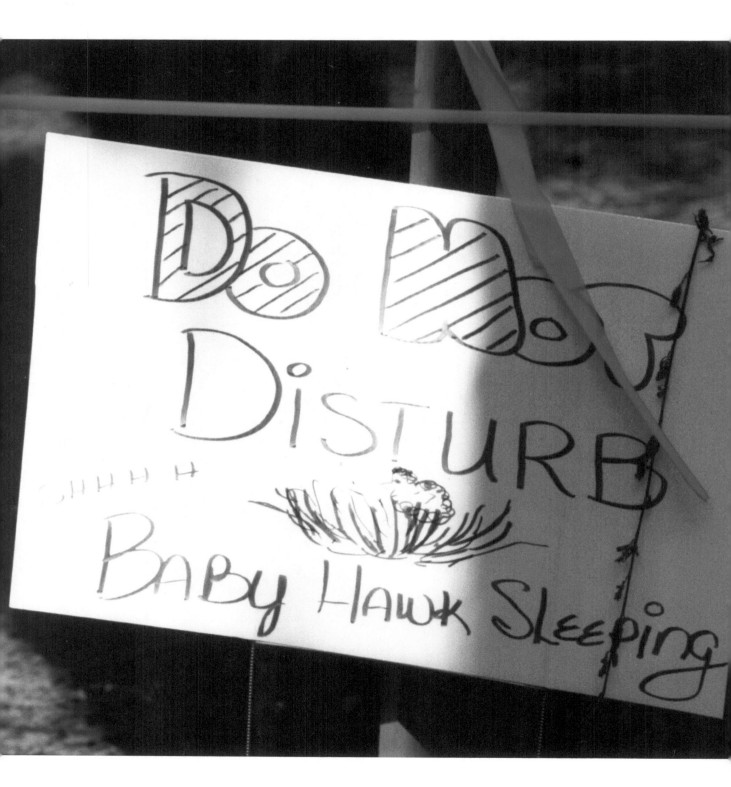

A family with lots of kids
 lived across the street
 from my new home.

They drew a picture of me
 and made a sign telling
 all the people that
 I was now part
 of the duck pond.

Other neighbors put up
 orange tape
 around my stand
 to protect me.

What is something nice
you have done
to help someone?

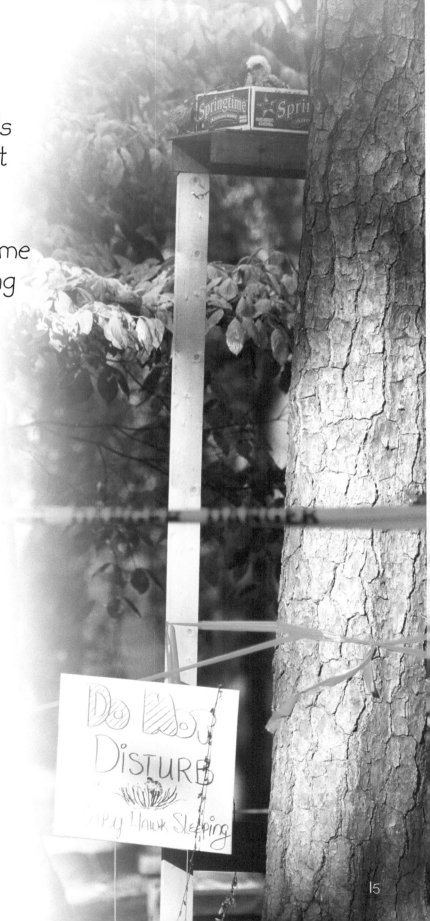

I could *see* my mom and dad
 flying around above me.

I could also hear them
 calling and calling to me.

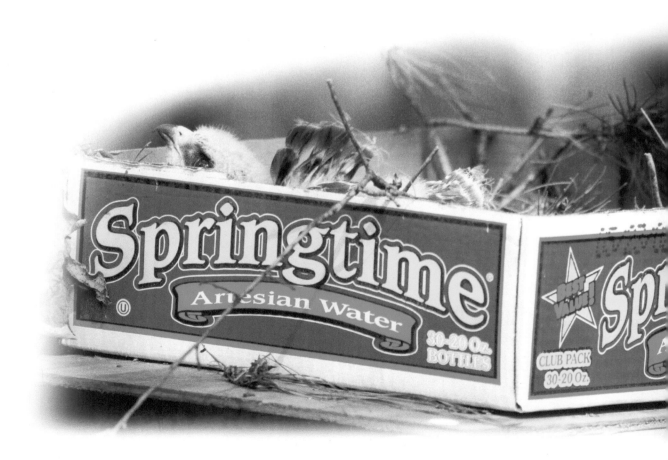

After 30 long minutes
 my mom landed on the box
 that I was nestled in
 and came to me.

Wow! I was so-o-o-o happy!

When have you missed
 your parents?

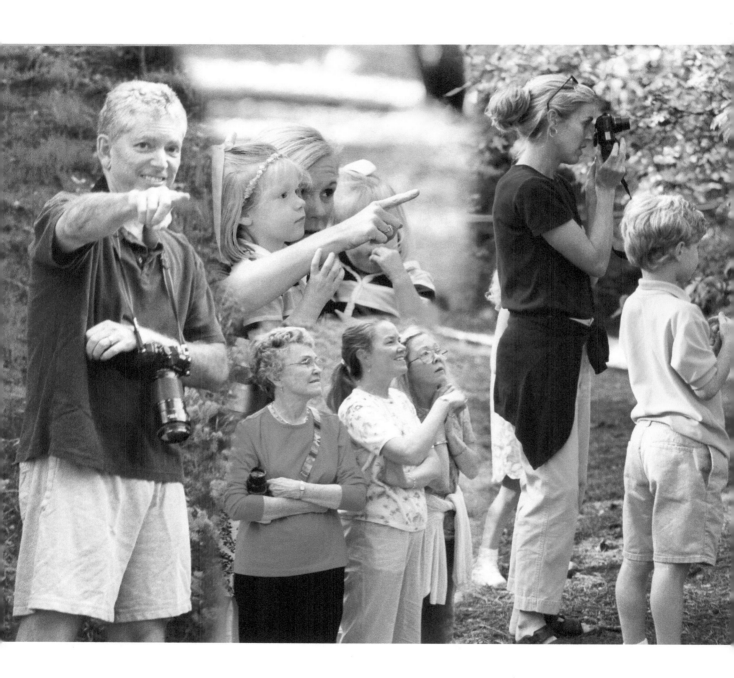

Every day the
Duck Pond
neighbors and
school children
would come
visit me.

They would watch whatever I was doing.

I don't think they had ever
 seen a hawk family up close.

Where would you like to go visit?

19

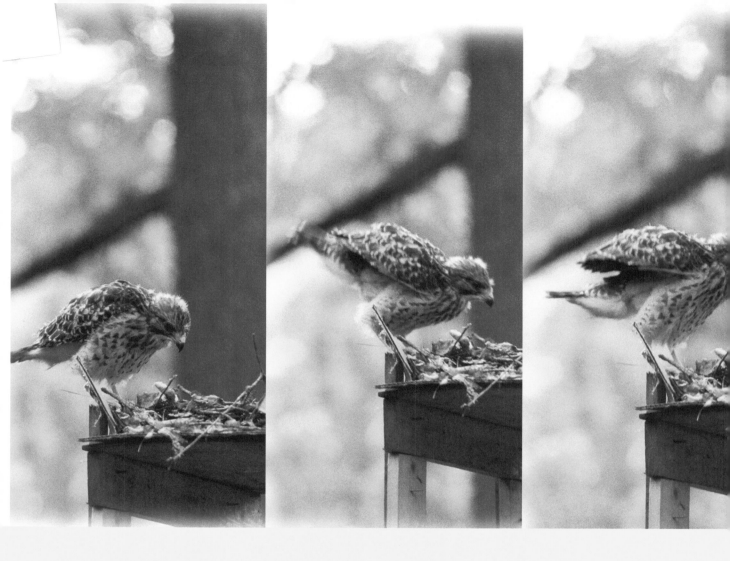

One time I scared everybody!

I balanced on the side of my box
 (they all gasped and
 were afraid I would fall) . . .

and just lifted my tail and pooped!

(Hawks don't go to the bathroom
 in their nest.)

I made everybody laugh!

What do you do
that makes
people laugh?

My good ole' mom and
 good ole' dad continued
 to take good care of me.

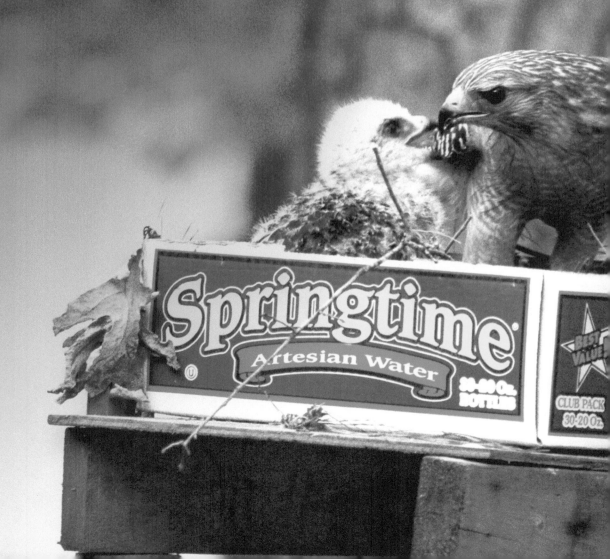

They brought me yummy mice,
 delicious snakes, tasty moles
 and only the best bugs to eat.

The people in the neighborhood
 continued to care about me and all that I did.

who else do you care about other than your family?

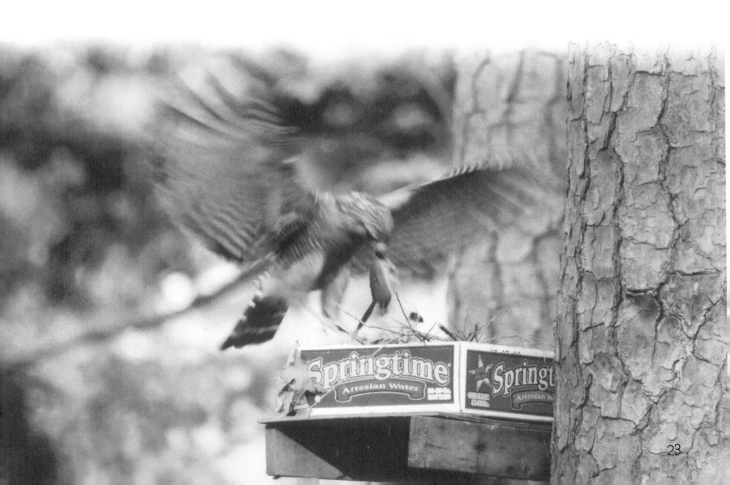

23

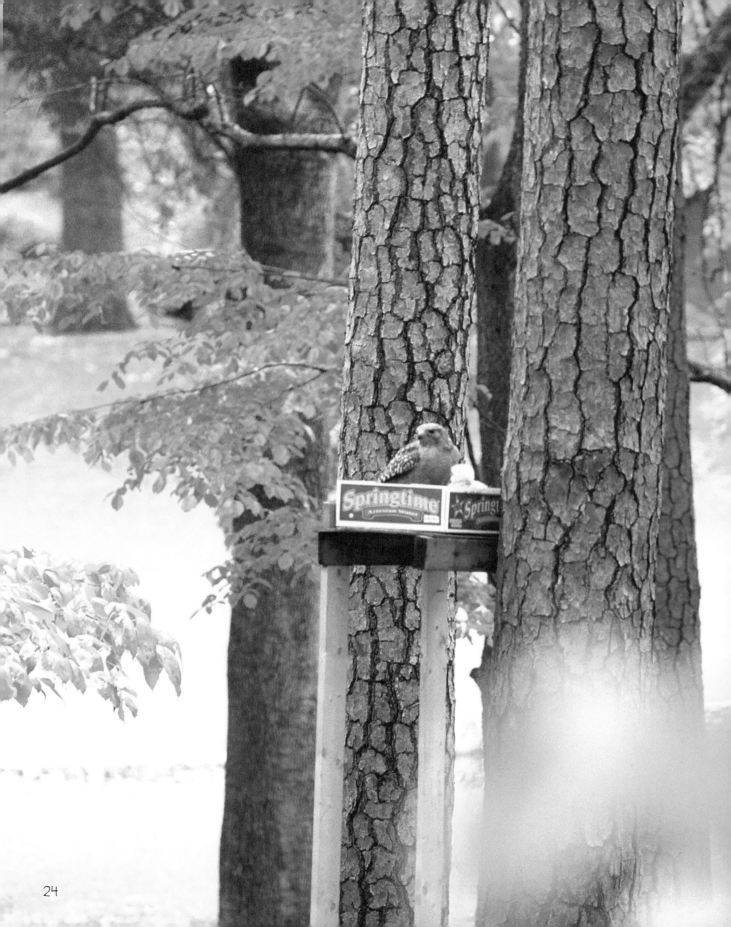

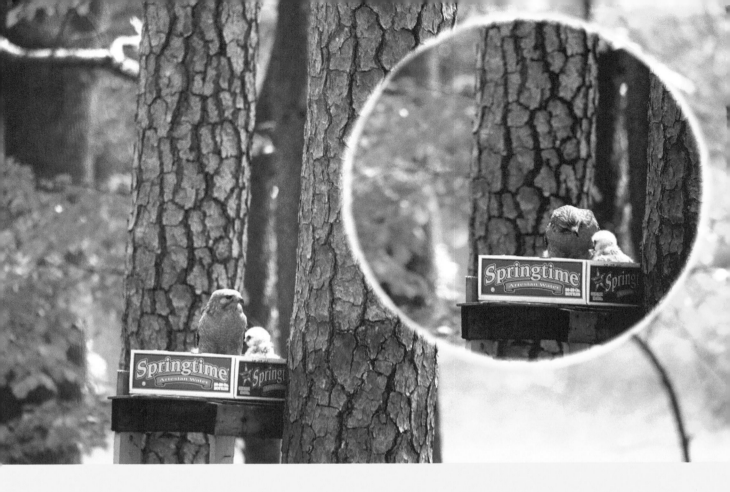

Day after day, I watched my mom and dad and all that they did.

They would wake me up, give me my meals, tell me to go to the bathroom, and preen myself (that is bird talk for "washing up" and "combing your hair").

I always do what they say because they want me to learn how to be a very good and smart grown-up hawk.

What do your parents try to teach you?

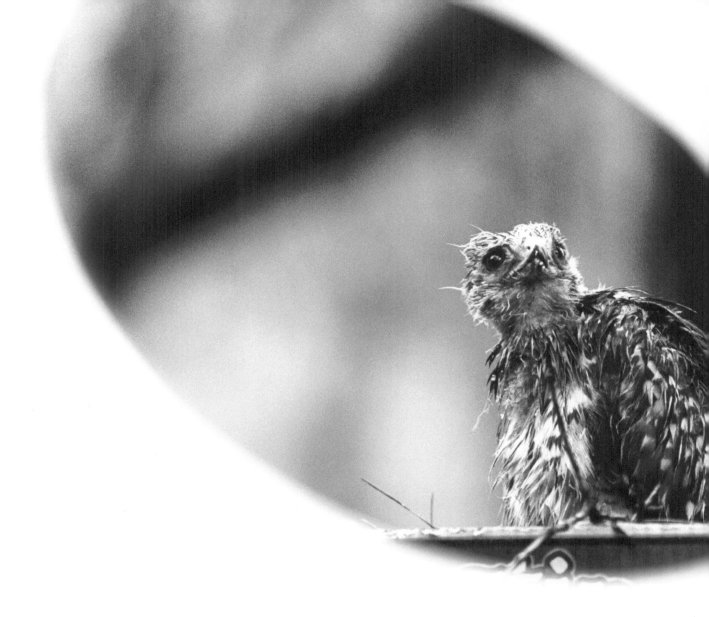

Sometimes there would be grey and rainy weather.

I didn't like those days because
 it was no fun and nothing seemed to go right.

I would get dripping wet
 and usually end up in a bad mood.

Living in a nest is not always easy!

What puts you in a bad mood?

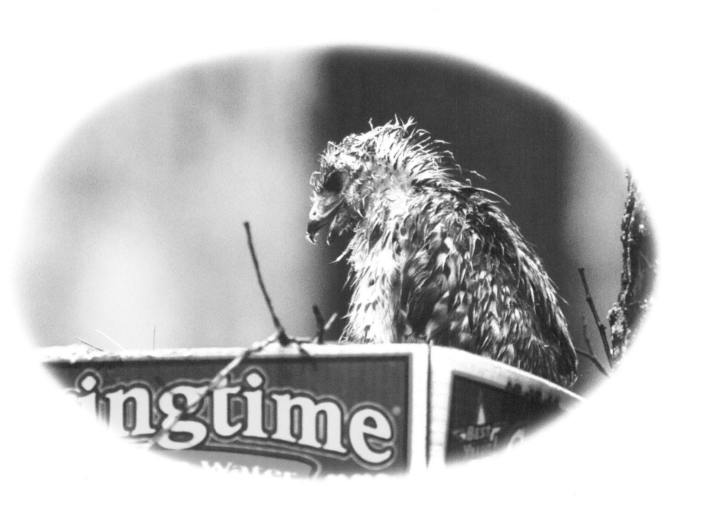

My feathers turned
 from being all white down to brown.

I was almost as big as my parents.

My mom told me I had
 to start flapping my wings
 so one day I could fly from the nest.

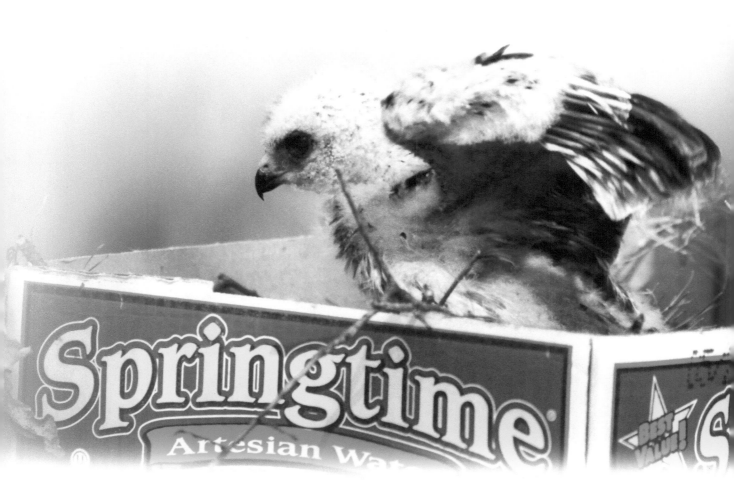

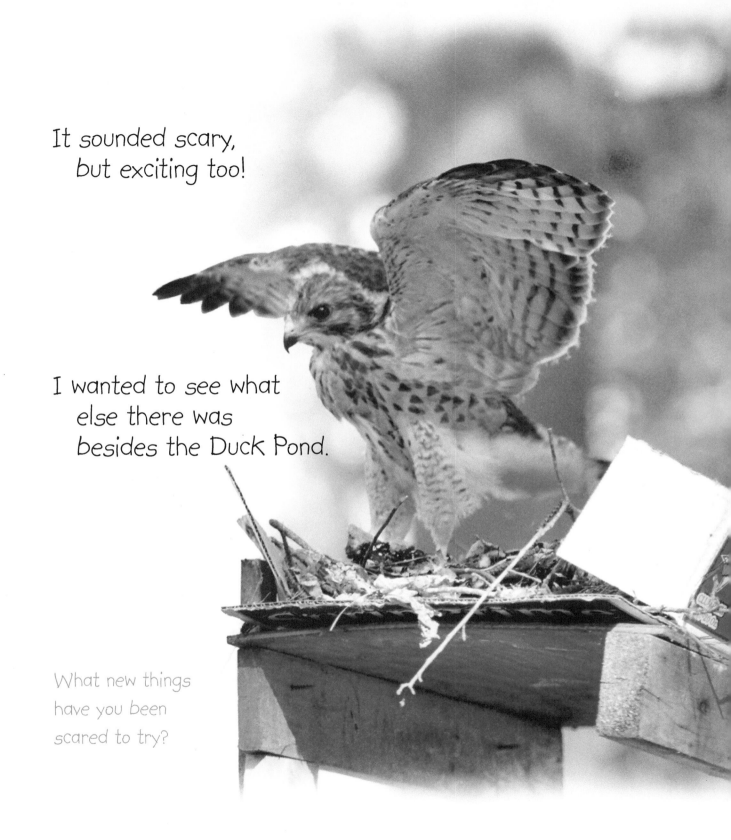

It sounded scary,
 but exciting too!

I wanted to see what
 else there was
 besides the Duck Pond.

What new things
have you been
scared to try?

ringtime®

Artesian Water

20-20 Oz.
BOTTLES

On the 15th day after Pearl
 found me I decided to fly!

I perched on the side of my box,
 fluttered my wings, and then
 pushed off from my home.

I flapped like I had seen
 my parents do and fell
 straight to the ground!

I didn't know what to do!

What have you tried
but could not do?

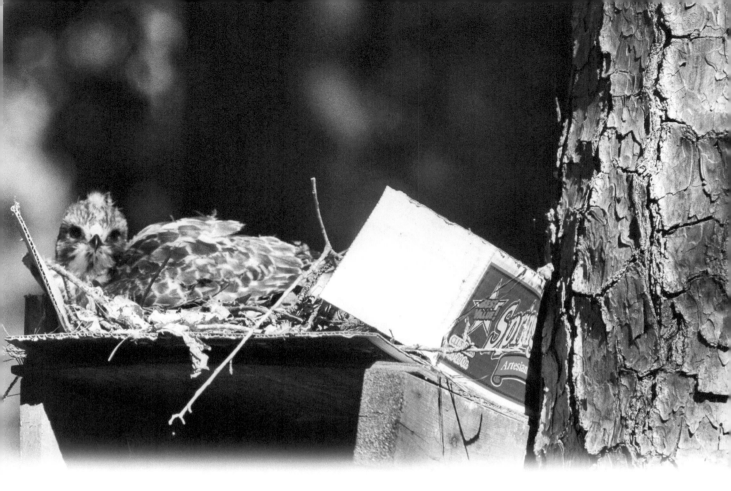

The neighbors were so concerned!

They saw me walking
on the ground and
they were worried that
I might not make
it through the night.

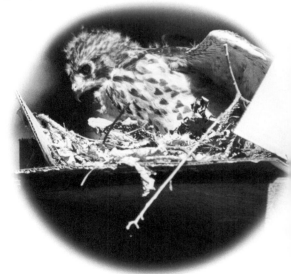

A gentle man put
on leather gloves,
climbed up a ladder
and put me back
in my nest.

What embarrasses you?

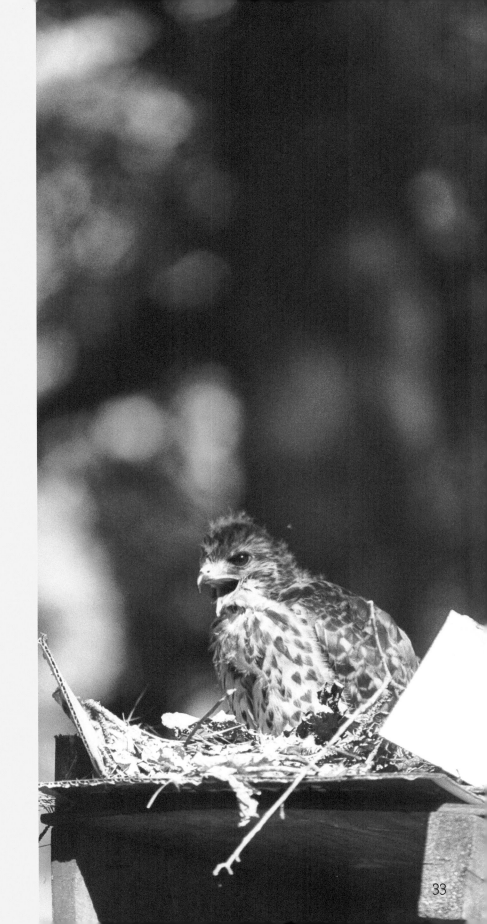

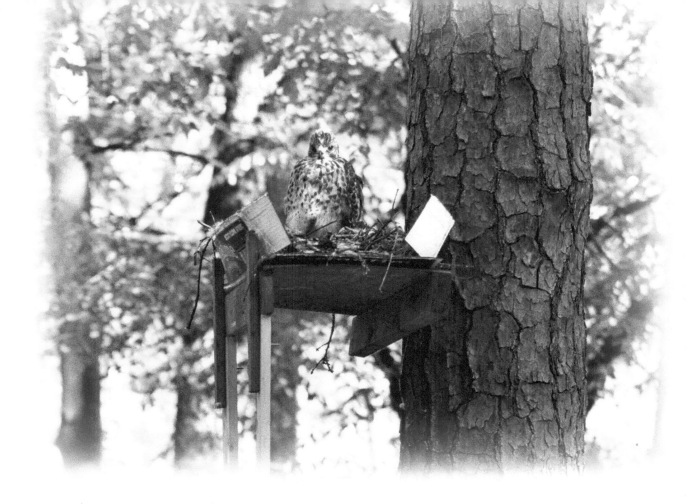

The morning of day number 16
 I decided I had to try again!

How was I ever going to be a real grownup hawk
 if I couldn't fly?

My wings went so fast, but I only had 10 feet to fall.

Very quickly, I hit the pine needles and dirt again.

One more time the neighbors came
 to my rescue and put me back in my home.

What grown up do you want to be like?

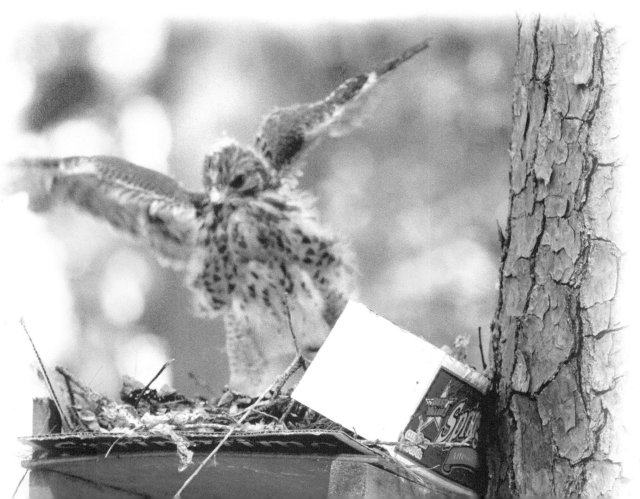

That afternoon I thought
only positive thoughts
and said a little prayer.

I set my sights on a dogwood tree
that was across from my stand.

I didn't fly far, but
I FLEW!

What makes you
proud of yourself?

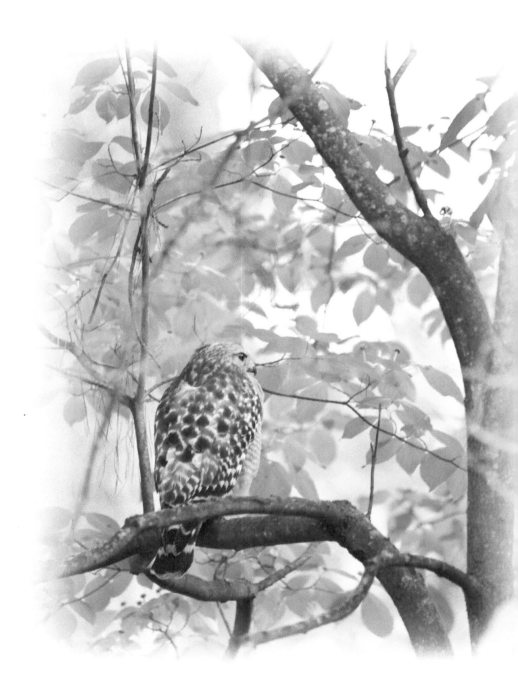

All the neighbors of the Duck Pond
 were sad to see me go!

I had become a part of their neighborhood.

They said to each other, "we have been blessed to
 watch this little hawk grow. He has brought us all
 joy. Now go beautiful bird and see all there is to
 see and be the grown up hawk God meant for you
 to be!"

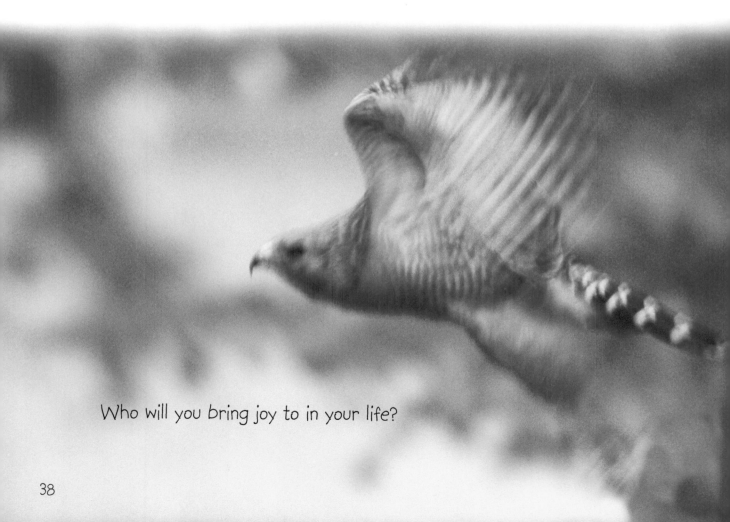

Who will you bring joy to in your life?

38

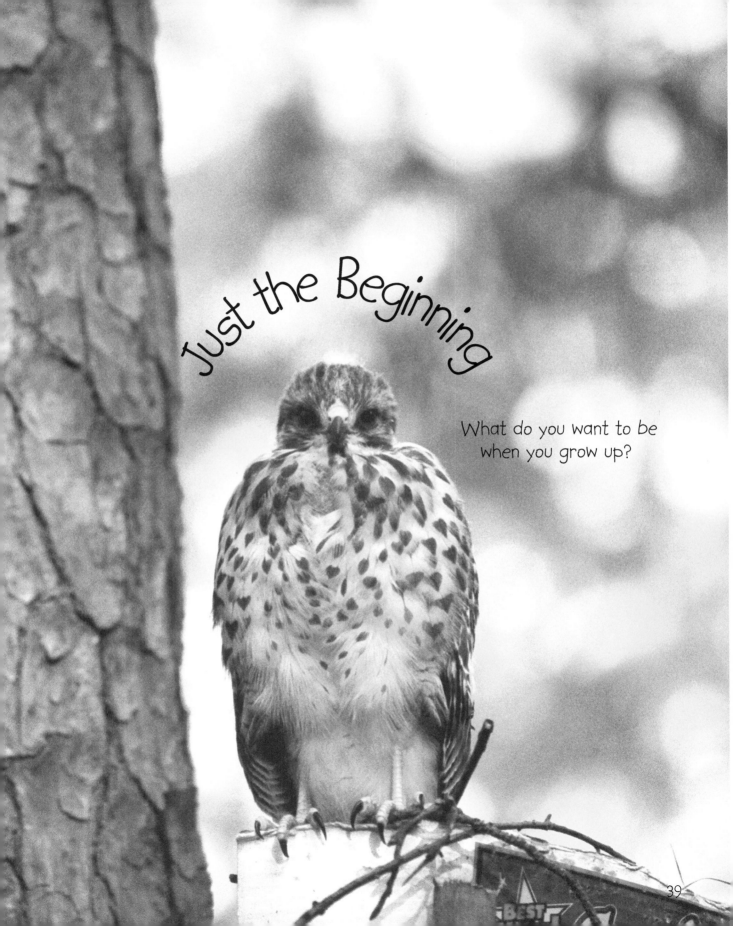

Just the Beginning

What do you want to be when you grow up?

The End

CPSIA information can be obtained
at www.ICGtesting.com
Printed in the USA
JSHW082119201222
35045JS00004B/5